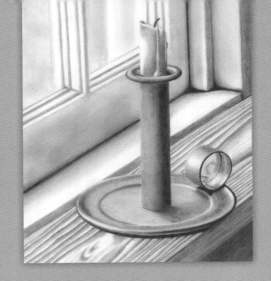

BEGINNING STILL LIFE

When drawing using only a simple graphite pencil, you can create beautiful works of art. The old masters of art didn't just spend their time painting; it was very important for them to learn to draw first, and a lot of time was spent on it. Some of their drawings are every bit as breathtaking as their works of oil. Drawing with graphite is a wonderfully satisfying medium, and it is vital to learn to draw if you wish to explore the many other mediums we have today, such as oil, acrylic, and watercolor. But if drawing is your main passion, I am sure you will someday create your own breathtaking works of art!

—Steven Pearce

CONTENTS

TOOLS & MATERIALS

Graphite pencil artwork requires few supplies, and fortunately they are fairly inexpensive. Choose professional pencils and paper, rather than student-grade materials; they will last longer and ensure a higher-quality presentation.

Pencils

Pencils are labeled based on their lead texture. Hard leads (H) are light in value and great for fine, detailed work, but they are more difficult to erase. Soft leads (B) are darker and wonderful for blending and shading, but they smudge easily. Medium leads, such as HB and F, are somewhere in the middle. Select a range of pencils between HB and 6B for variety. You can purchase wood-encased pencils or mechanical pencils with lead refills.

TIP

When you try a paper for the first time, practice and experiment on it. Draw, blend, and erase before starting your final work to see how it will perform. For the type of drawing we'll do in this book, I prefer to use an acid-free Bristol smooth paper or a high-quality 100% cotton rag, hot-pressed watercolor paper.

Paper

Paper has a tooth, or texture, that holds graphite. Papers with more tooth have a rougher texture and hold more graphite, which allows you to create darker values. Smoother paper has less tooth and holds less graphite, but it allows you to create much finer detail. Plan ahead when beginning a new piece, and select paper that lends itself to the textures in your drawing subject.

Blending Tools

There are several tools you can use to blend graphite for a smooth look. The most popular blenders are blending stumps, tortillons, and chamois cloths. Never use your finger to blend—it can leave oils on your paper, which will show after applying graphite.

Stumps Stumps are tightly rolled paper with points on both ends. They come in various sizes and are used to blend large and small areas of graphite, depending on the size of the stump. You can also use stumps dipped in graphite shavings for drawing or shading.

Tortillons Tortillons are rolled more loosely than a stump. They are hollow and have one pointed end. Tortillons also come in various sizes and can be used to blend smaller areas of graphite.

Facial Tissue This is one of my favorite blending tools. You can wrap it around your finger or roll it into a point. I mostly use it when drawing very smooth surfaces. Make sure you use plain facial tissue, without added moisturizer.

Chamois Chamois are great for blending areas into a soft tone. These cloths can be used for large areas or folded into a point for smaller areas. When the chamois becomes embedded with graphite, simply throw them into the washer or wash by hand. I usually keep one with graphite on it to create large areas of light shading. To create darker areas of shading, I add graphite shavings to the chamois.

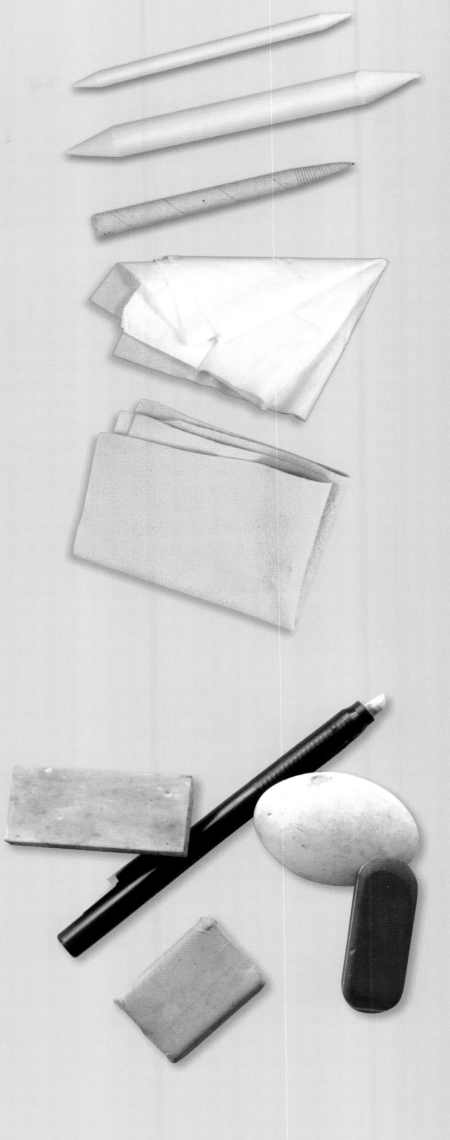

Erasers

Erasers serve two purposes: to eliminate unwanted graphite and to "draw" within existing graphite. There are many different types of erasers available.

Kneaded This versatile eraser can be molded into a fine point, a knife-edge, or a larger flat or rounded surface. It removes graphite gently from the paper but not as well as vinyl or plastic erasers.

Block Eraser A plastic block eraser is fairly soft, removes graphite well, and is very easy on your paper. I use it primarily for erasing large areas, but it also works quite well for doing a final cleanup of a finished drawing.

Stick Eraser Also called "pencil erasers," these handy tools hold a cylindrical eraser inside. You can use them to erase areas where a larger eraser will not work. Using a utility razor blade, you can trim the tip at an angle or cut a fine point to create thin white lines in graphite. It's like drawing with your eraser!

BASIC TECHNIQUES

Here are some of the basic techniques I use to create the drawings in this book. Practicing a new technique first will save you from doing a lot of erasing later! There are many more techniques to discover that apply to other styles of drawing, so keep exploring after you have mastered these techniques.

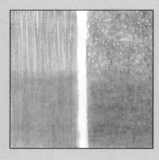

Blending

When you use a blending tool, you move already-applied graphite across the paper, causing the area to appear softer or more solid. I like using a circular motion when blending to achieve a more even result. Here are two examples of drawing techniques blended with a tortillon. On your practice paper, experiment with the various blending tools mentioned in this book.

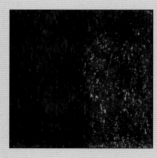

Burnishing

When you use a soft pencil, the result may appear grainy depending on the tooth of the paper. In some of your drawings, you may desire this look. However, if the area requires a more solid application, simply use a pencil that is a grade or two harder to push, or "burnish," the initial layer of graphite deeper into the tooth of the paper.

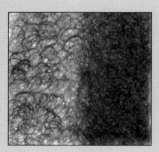

Circular

I use this method often. Simply move the pencil in a continuous, overlapping, and random circular motion. You can use this technique loosely or tightly, as shown in this example. You can leave the circular pattern as is to produce rough textures, or you can blend to create smoother textures.

Erasers

Pencil and kneaded erasers are a must. The marks on the left side of this example were created with a pencil eraser, which can be used for erasing small areas. If you sharpen it, you can "draw" with it. The kneaded eraser is useful for pulling graphite off the paper in a dabbing motion, as shown on the right side.

Applying Graphite with a Blender

Chamois Using a chamois is a great way to apply graphite to a large area. Wrap it around your finger and dip it in saved graphite shavings to create a dark tone, or use what may be already on the chamois to apply a lighter tone.

Stump Stumps are great not only for blending but also for applying graphite. Use an old stump to apply saved graphite shavings to both large and small areas. You can achieve a range of values depending on the amount of graphite on the stump.

Linear Hatching

In linear hatching, use closely drawn parallel lines for tone or shading. You can gradually make the lines darker or lighter to suggest shadow or light. Draw varying lengths of lines very close and blend for a smooth finish. You can also curve your lines to follow the contour of an object, such as a vase.

Negative Drawing

Use your pencil to draw in the *negative space*—the area around the desired shape—to create the object. In this example, I drew around the vine and leaves, leaving the white of the paper—the *positive space*—as my desired shapes.

Scribbling

You can use random scribbling, either loose or tight, to create a variety of textures such as old leather, rusty metal, rocks, bricks, and more. I even use it for rendering the rough skin of some animals, like elephants. Lightly blend the scribbling to produce different effects.

Stippling

Tap the paper with the tip of a sharp pencil for tiny dots or a duller tip for larger dots, depending on the size you need. Change the appearance by grouping the dots loosely or tightly. You can also use the sharp tip of a used stump or tortillon to create dots that are lighter in tone.

SHAPE & CONTOUR

This simple composition of a pear and two apples on a white background explores composition, shape, and basic value shading. Developing realistic shape and contour as well as effective contrast will help develop a convincing three-dimensional look.

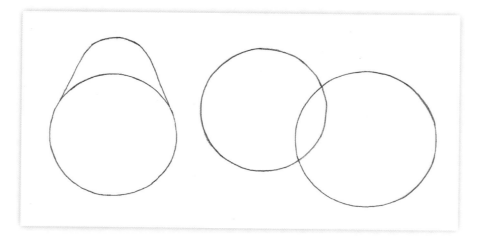

Sketch three slightly different-sized circles, and block in the top of the pear shape.

The apples and pear are not perfectly formed, so you will need to reshape some areas. The apple in the middle is slightly wider at the sides, and the contours of the pear are not perfectly rounded.

Add the stems, and lightly draw in the areas where the shadows, highlights, and reflections will be.

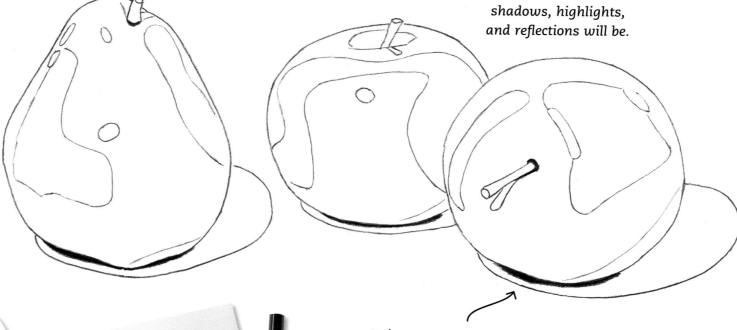

Using a 4B pencil, draw in the darkest values first in the cast shadows and at the base of the two outer fruits' stems.

TIP

When in the beginning stages, draw your lines even lighter than what you see here. To reduce smudges, keep a clean piece of paper under your drawing hand as you work.

TIP

Drawing in the darkest values helps you envision all of the values you will use to create effective contrast and a realistic, three-dimensional look.

Using small, circular, overlapping strokes, fill in the darker-value areas on the pear and the apple on the right. Use slightly lighter pressure around the edges of these areas, creating a gradation.

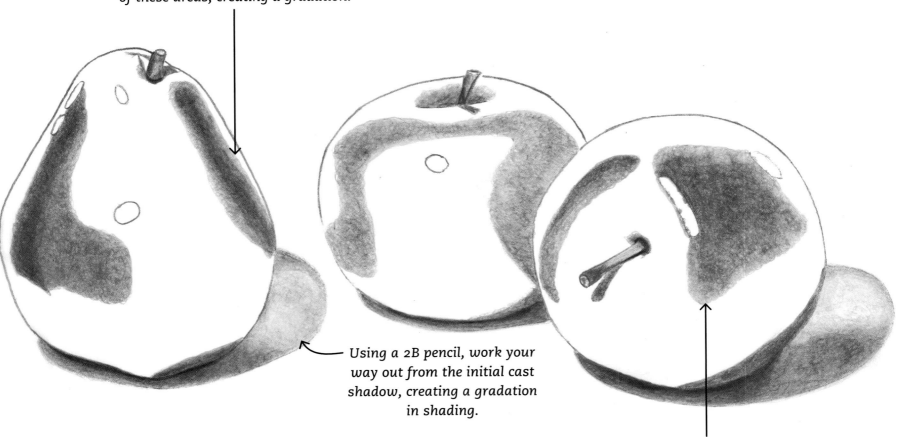

Using a 2B pencil, work your way out from the initial cast shadow, creating a gradation in shading.

Switch to an HB pencil or use less pressure to finish the lighter areas. Use a 2B and an HB pencil to create the different values on and around the stems.

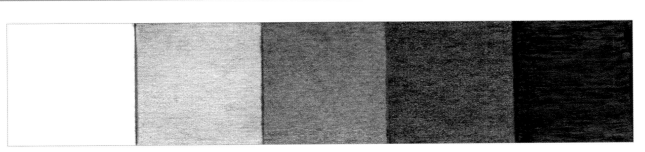

| White of the paper | HB lead | 2B lead | 4B lead | 6B lead |

Graphite can produce every value from light gray to black, depending on the pencil choice and the amount of pressure applied. A value scale helps us choose the right pencils and pressure to use in a drawing.

Continue with overlapping circular strokes on the lighter areas using an HB pencil. Leave some white of the paper to show the highlighted areas on the fruit.

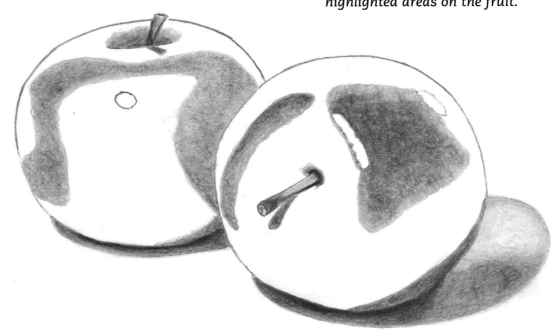

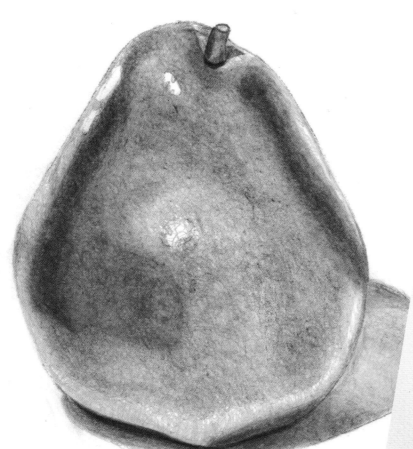

Use a 2H pencil where the light reflects from the table to the bottom areas of the fruit.

TIP

Avoid simply using heavy pressure to create darker values. Become familiar with the different hardnesses of the pencils and the values they create.

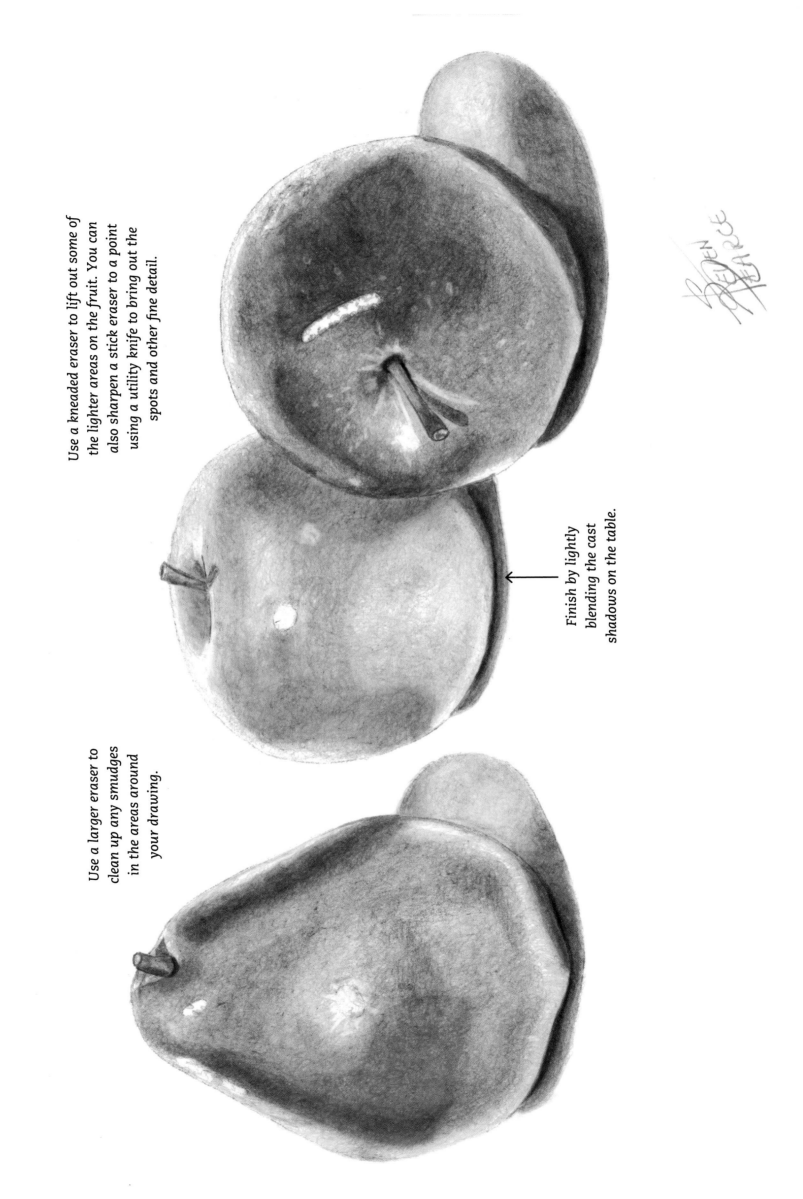

Use a kneaded eraser to lift out some of the lighter areas on the fruit. You can also sharpen a stick eraser to a point using a utility knife to bring out the spots and other fine detail.

Finish by lightly blending the cast shadows on the table.

Use a larger eraser to clean up any smudges in the areas around your drawing.

PERSPECTIVE & VALUE

This drawing of an old Brownie Camera, a type of Art Deco camera produced in the 1940s and 1950s, is a great exercise for building confidence in perspective and value shading. Use perspective to angle the camera, and take the time to study and build up the different values within the drawing.

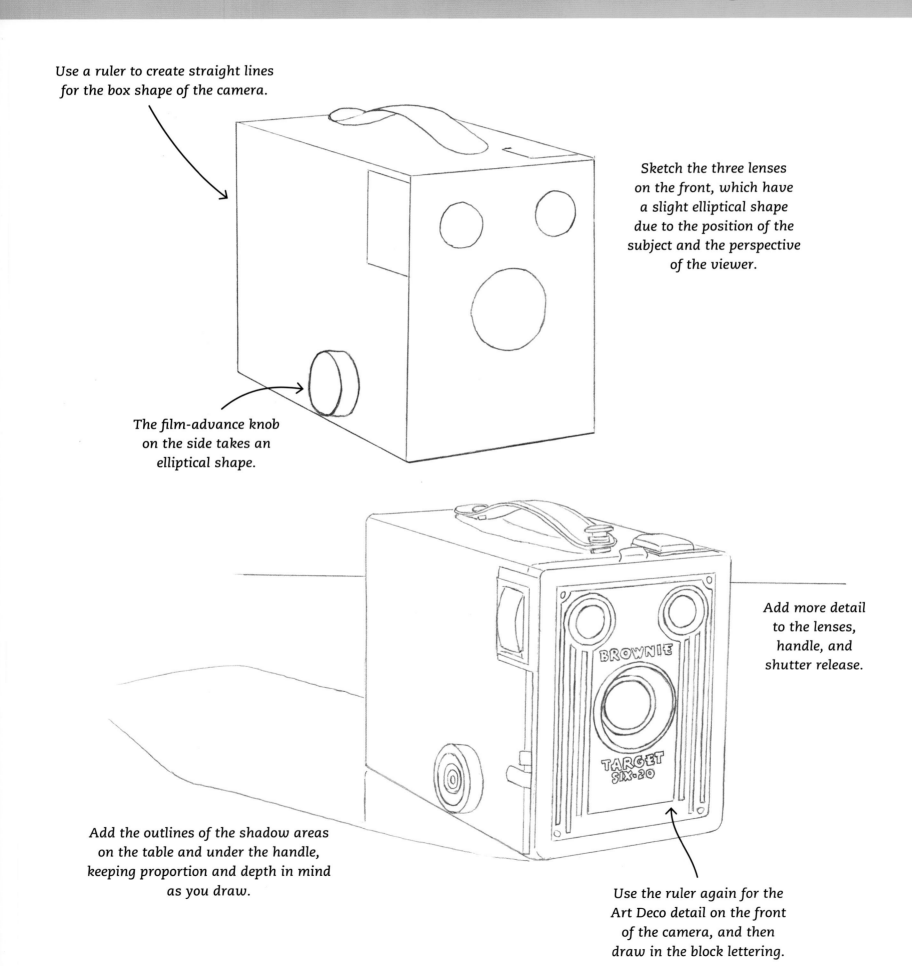

Use a ruler to create straight lines for the box shape of the camera.

Sketch the three lenses on the front, which have a slight elliptical shape due to the position of the subject and the perspective of the viewer.

The film-advance knob on the side takes an elliptical shape.

Add more detail to the lenses, handle, and shutter release.

Add the outlines of the shadow areas on the table and under the handle, keeping proportion and depth in mind as you draw.

Use the ruler again for the Art Deco detail on the front of the camera, and then draw in the block lettering.

BROWNIE

TARGET SIX·20

TIP

You may want to start this drawing on a different piece of drawing paper to get the proportions and details of the camera just right, and then trace it onto a fresh sheet of drawing paper.

Using a 4B pencil, start shading in the darkest values of the drawing. The subject is very dark in color, but it contains a subtle assortment of values around its face and edges. Really study the camera to discern the different areas of shading and value.

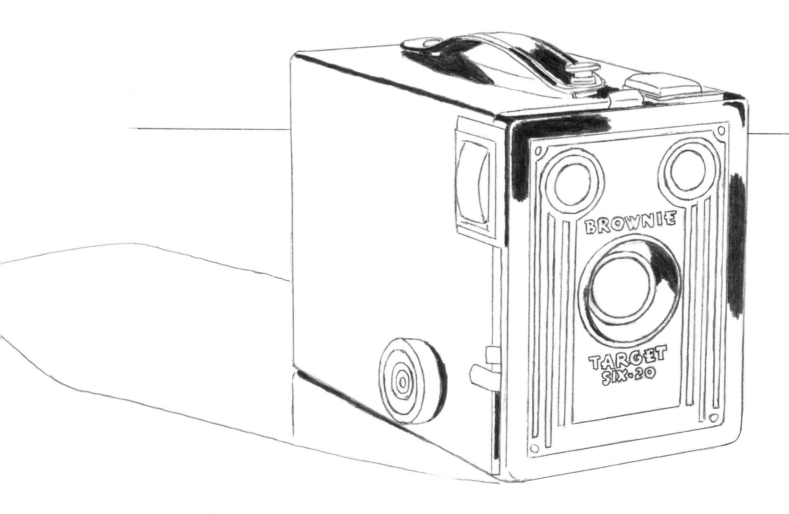

Using a technique called "negative drawing," fill in the areas around the lettering and the design using a 2B pencil. This emphasizes the lettering and lines on the front of the camera.

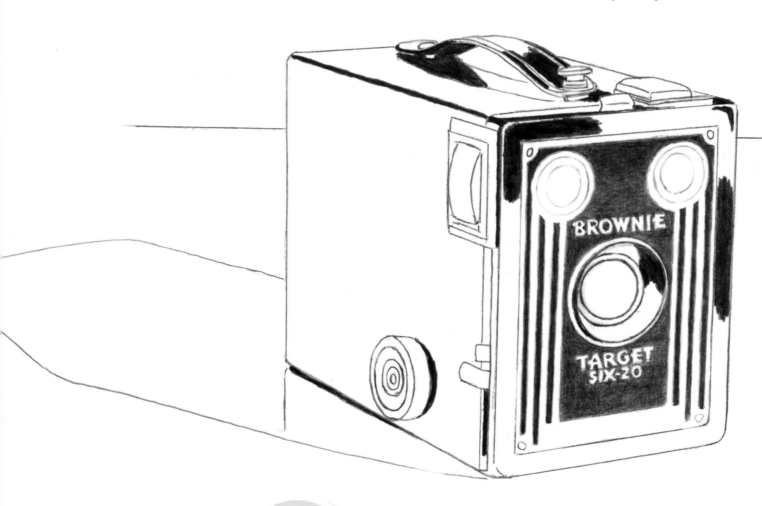

TIP

Linear hatching uses close, parallel lines to create value shading (see technique on page 5). This creates a weathered and worn look around the edges of the camera.

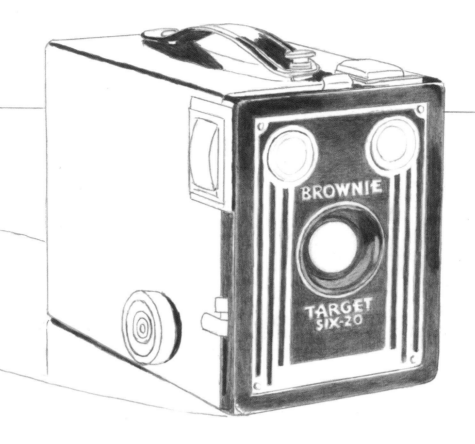

To finish the face of the camera, use a 2B pencil to add value with linear hatching, leaving the edges lighter.

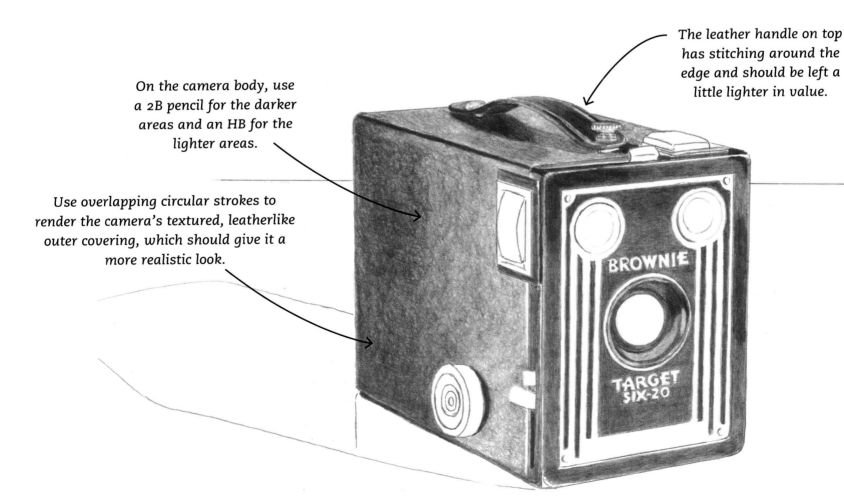

The leather handle on top has stitching around the edge and should be left a little lighter in value.

On the camera body, use a 2B pencil for the darker areas and an HB for the lighter areas.

Use overlapping circular strokes to render the camera's textured, leatherlike outer covering, which should give it a more realistic look.

TIP

You can make your background much simpler than what you see in real life or in a reference photo. For this drawing, I placed the horizon line at eye level and added shading for dimension.

Keep your pencil very sharp for the finer details.

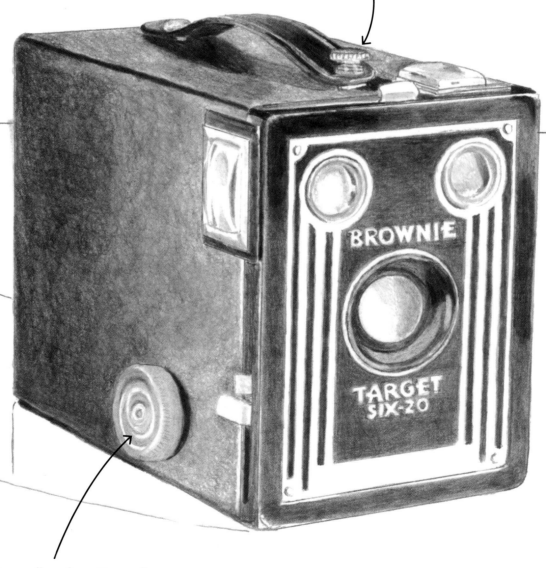

Use an HB pencil and a 2H pencil to give detail to the lenses and the knob. Lightly blend these areas using a tortillon.

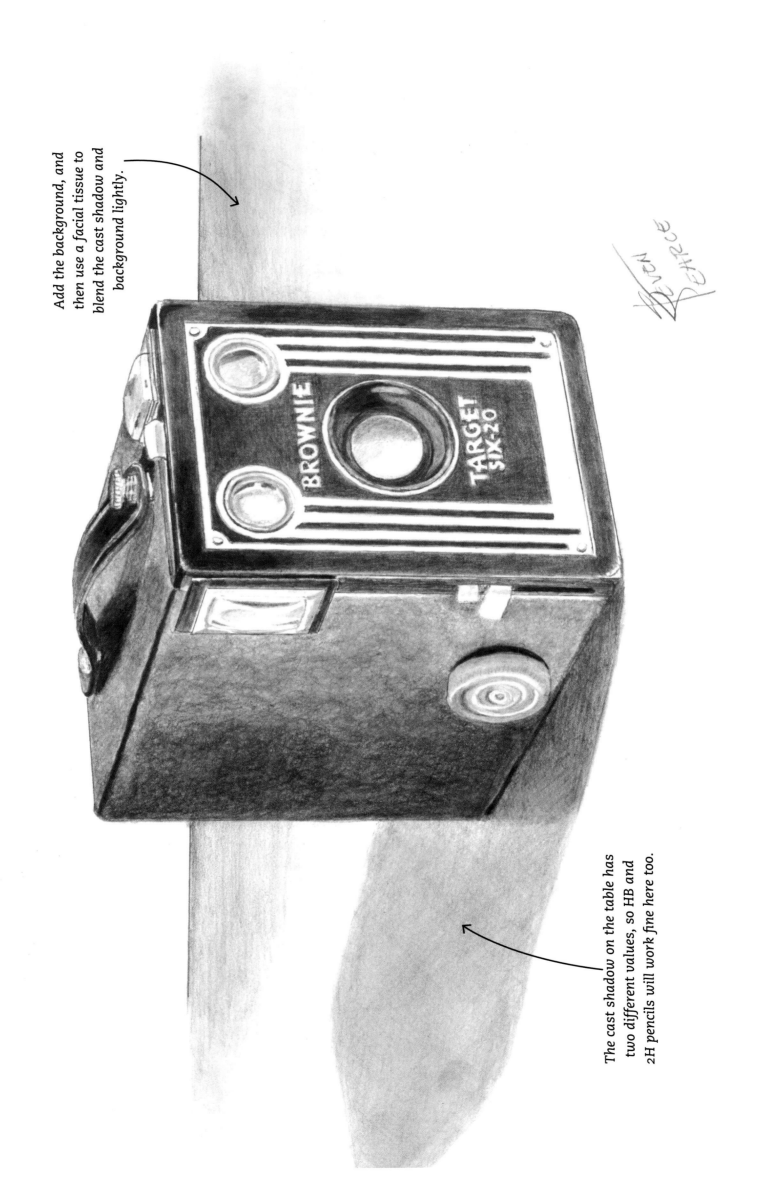

Add the background, and then use a facial tissue to blend the cast shadow and background lightly.

The cast shadow on the table has two different values, so HB and 2H pencils will work fine here too.

DRAWING ELLIPSES

In this project, an old-fashioned tin candlestick sitting on a windowsill provides the perfect opportunity to practice drawing ellipses. Ellipses can be a challenge to draw because the eye is very good at picking up imperfections. If you plan on drawing a lot of still life, learning to draw ellipses is a must.

The basic structure of the candlestick is mostly made up of ellipses and straight lines. If you like, you can start on a separate piece of paper to achieve the proportions you are happy with, and then trace onto the drawing paper.

An ellipse is a circle that appears elongated because of the viewer's perspective. Notice the gradual change in the ellipse at various degrees of angles.

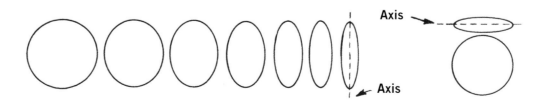

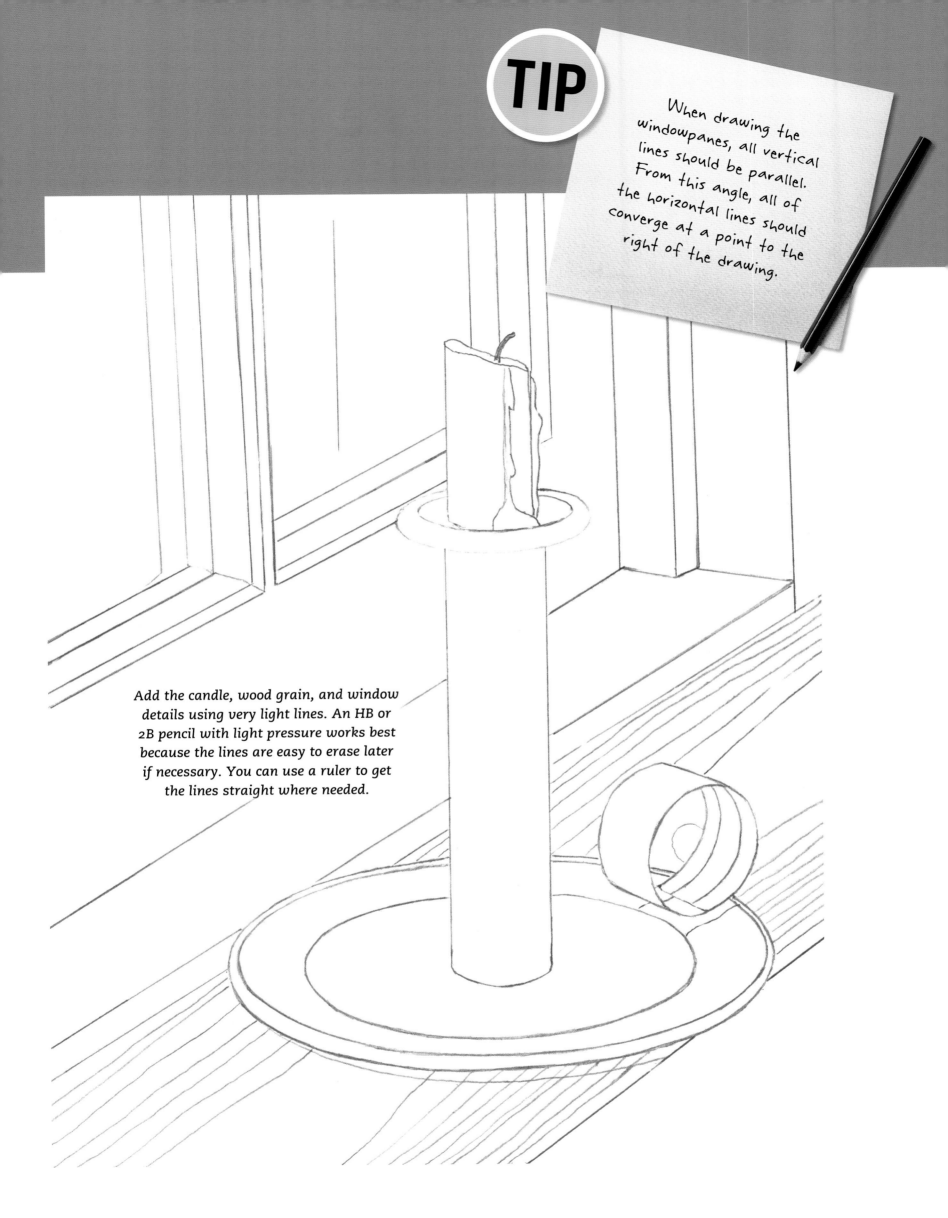

TIP

When drawing the windowpanes, all vertical lines should be parallel. From this angle, all of the horizontal lines should converge at a point to the right of the drawing.

Add the candle, wood grain, and window details using very light lines. An HB or 2B pencil with light pressure works best because the lines are easy to erase later if necessary. You can use a ruler to get the lines straight where needed.

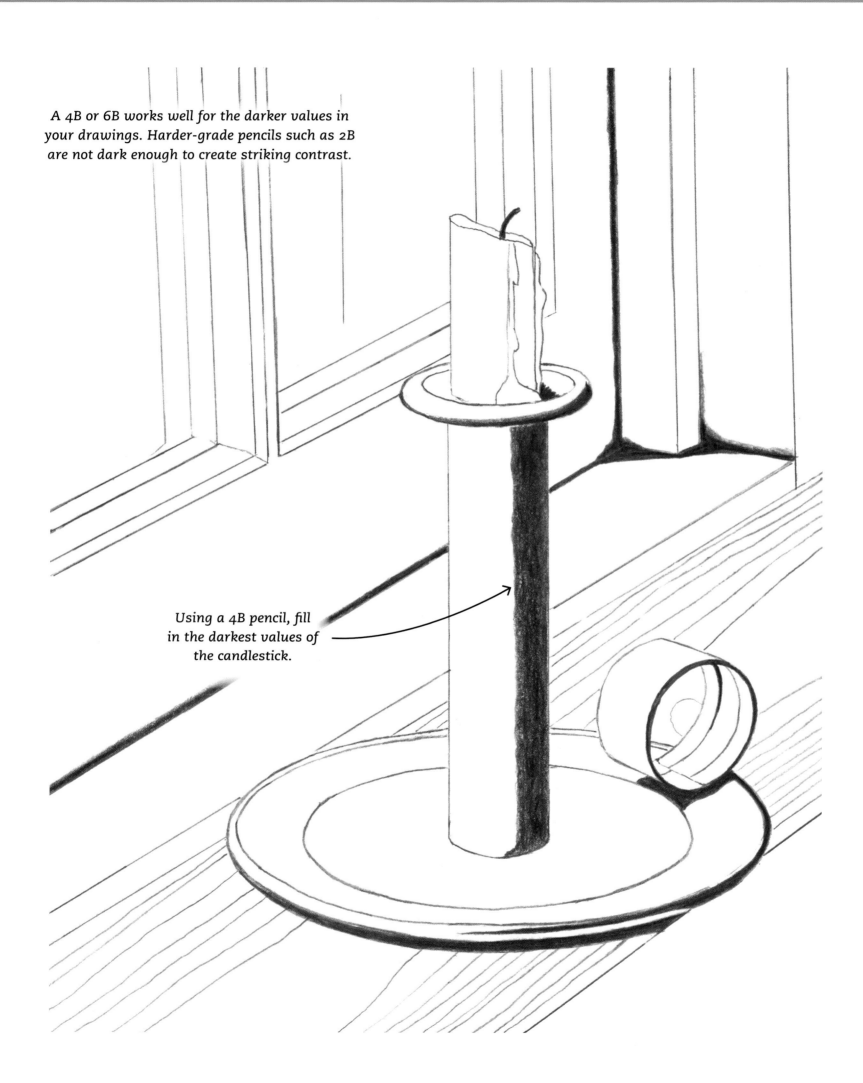

A 4B or 6B works well for the darker values in your drawings. Harder-grade pencils such as 2B are not dark enough to create striking contrast.

Using a 4B pencil, fill in the darkest values of the candlestick.

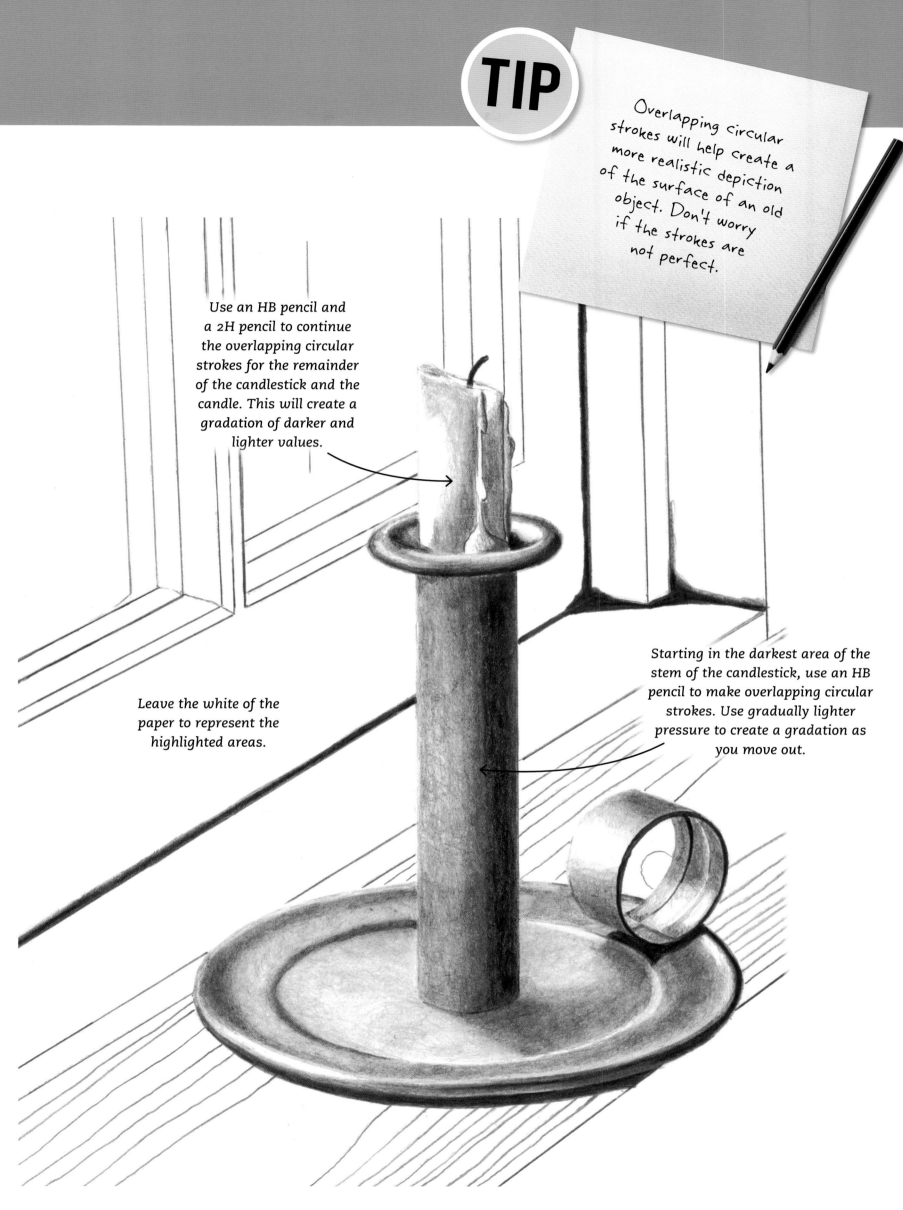

TIP

Overlapping circular strokes will help create a more realistic depiction of the surface of an old object. Don't worry if the strokes are not perfect.

Use an HB pencil and a 2H pencil to continue the overlapping circular strokes for the remainder of the candlestick and the candle. This will create a gradation of darker and lighter values.

Leave the white of the paper to represent the highlighted areas.

Starting in the darkest area of the stem of the candlestick, use an HB pencil to make overlapping circular strokes. Use gradually lighter pressure to create a gradation as you move out.

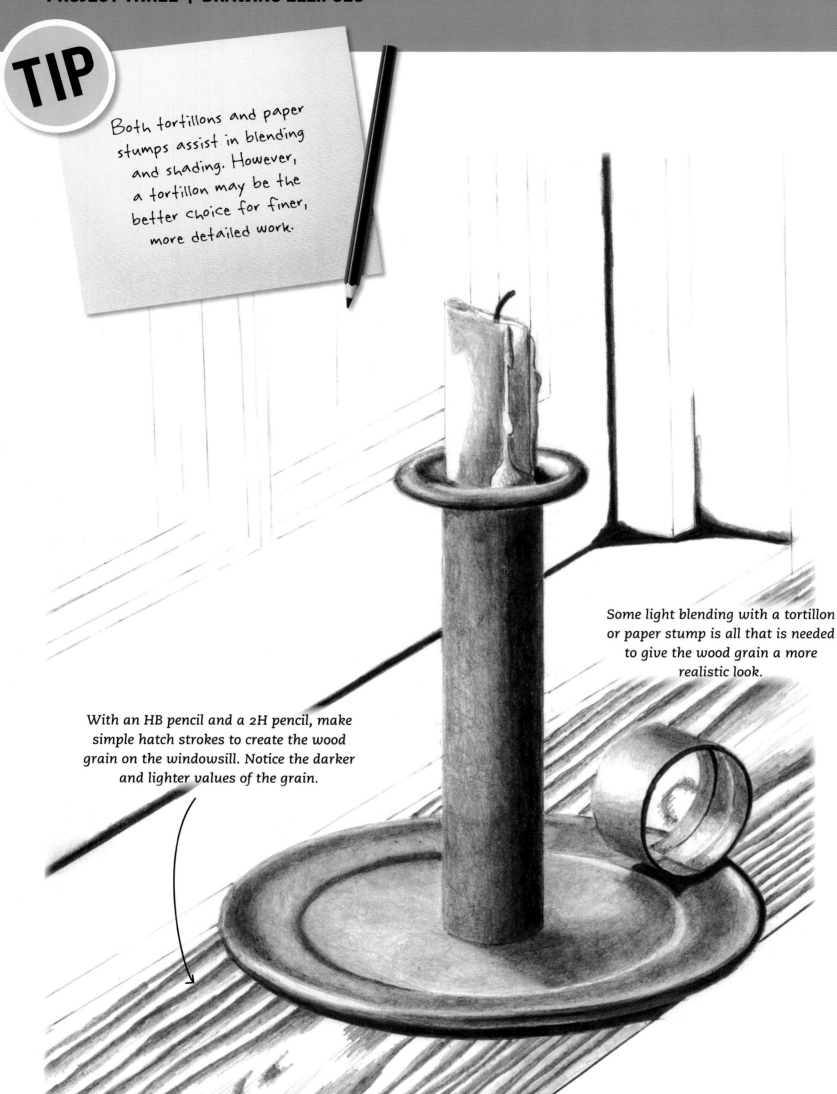

TIP

Both tortillons and paper stumps assist in blending and shading. However, a tortillon may be the better choice for finer, more detailed work.

Some light blending with a tortillon or paper stump is all that is needed to give the wood grain a more realistic look.

With an HB pencil and a 2H pencil, make simple hatch strokes to create the wood grain on the windowsill. Notice the darker and lighter values of the grain.

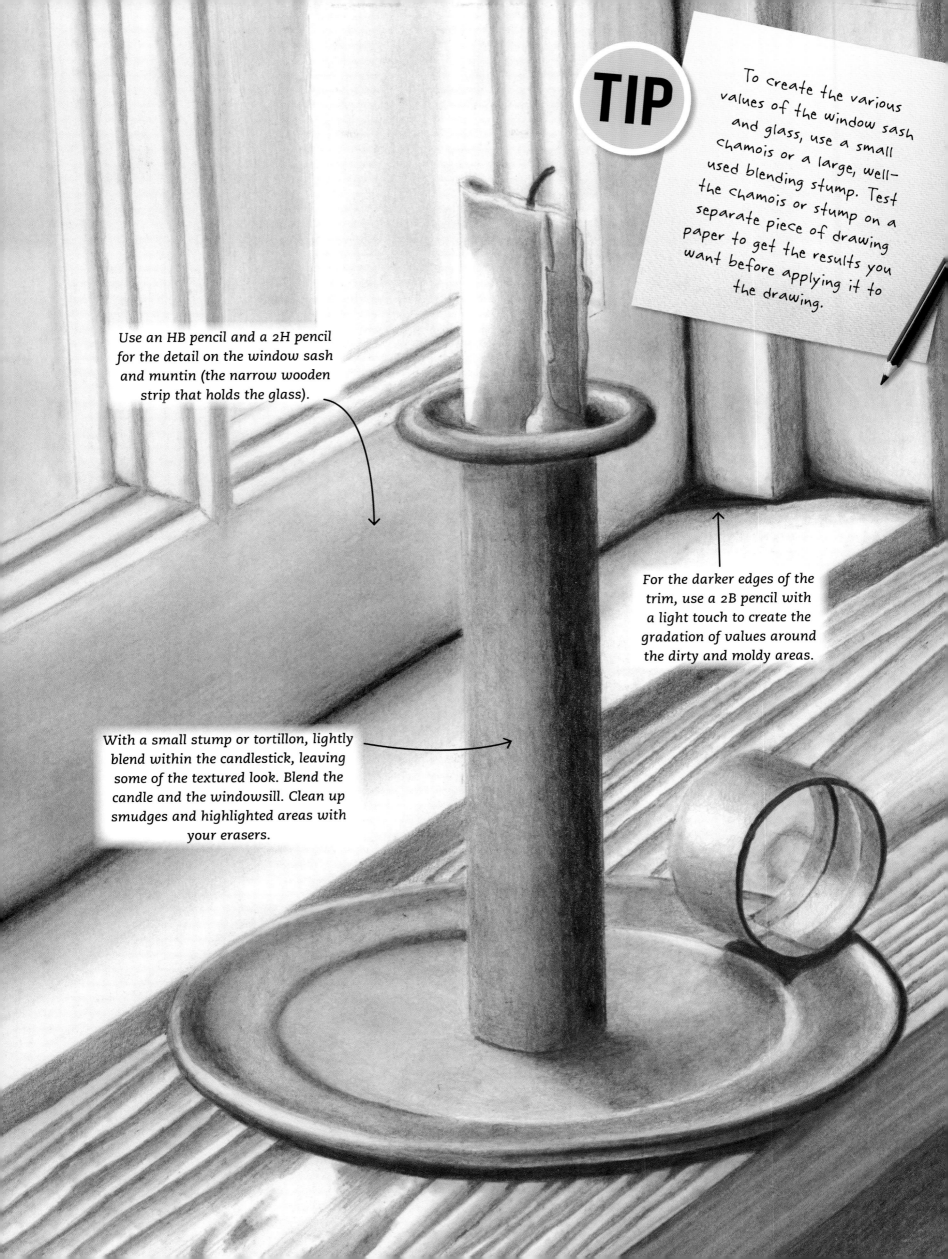

Use an HB pencil and a 2H pencil for the detail on the window sash and muntin (the narrow wooden strip that holds the glass).

For the darker edges of the trim, use a 2B pencil with a light touch to create the gradation of values around the dirty and moldy areas.

With a small stump or tortillon, lightly blend within the candlestick, leaving some of the textured look. Blend the candle and the windowsill. Clean up smudges and highlighted areas with your erasers.

BLENDING

This drawing of an old teapot is a great project for practicing a variety of techniques, such as drawing overlapping circular strokes and applying graphite with a blending stump and a small square of chamois. These simple techniques help create a more realistic drawing.

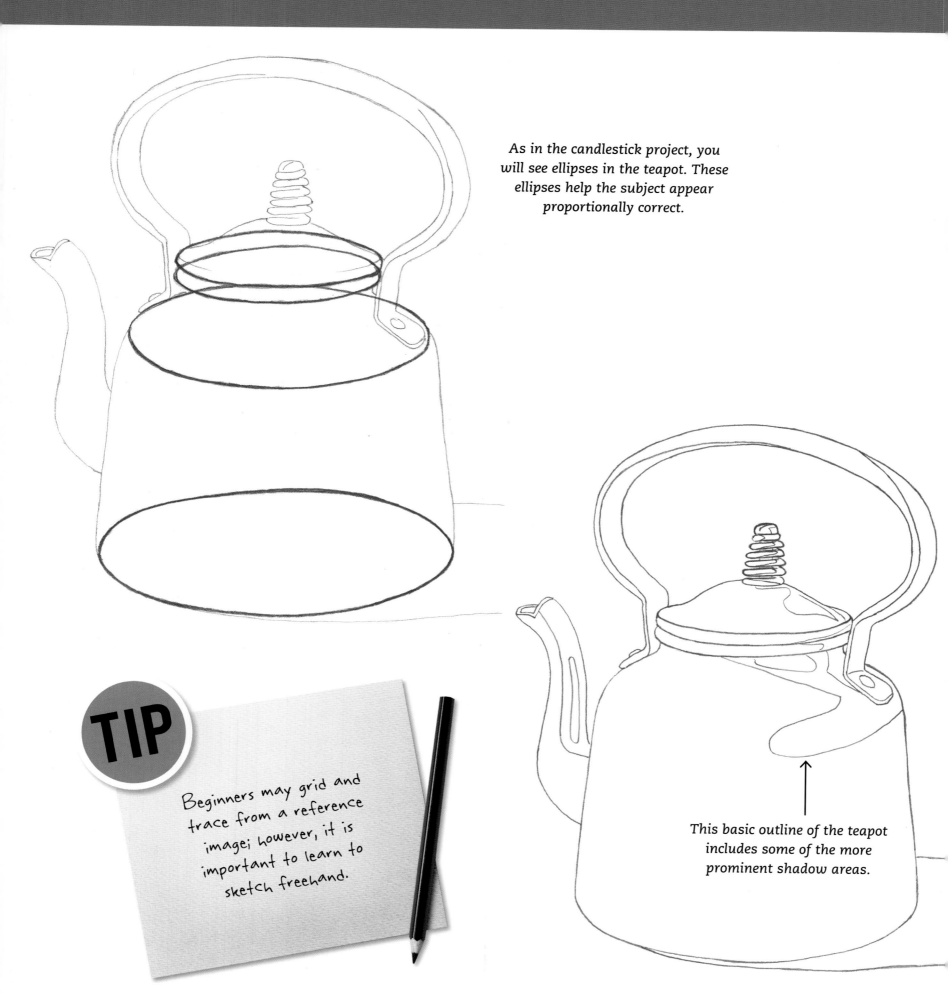

As in the candlestick project, you will see ellipses in the teapot. These ellipses help the subject appear proportionally correct.

TIP

Beginners may grid and trace from a reference image; however, it is important to learn to sketch freehand.

This basic outline of the teapot includes some of the more prominent shadow areas.

On some papers that have more "tooth," meaning they are not as smooth, a soft pencil may not be able to completely cover the area. Using a harder-grade pencil will help push the graphite already applied deeper into the paper, so less white shows through.

Using a 4B pencil, identify and fill in the darkest shadow areas of the teapot. Leave the dark shadow of the teapot handle a little rough at the edges; later you can create a smooth transition from darker to lighter values.

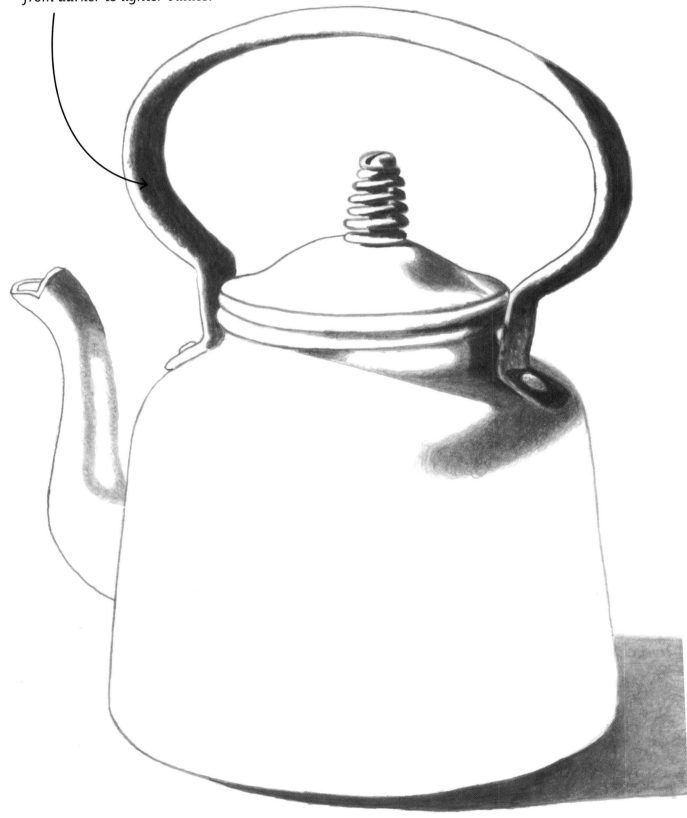

Using a 2B pencil and an HB pencil in an overlapping circular motion, fill in the shadow areas with the next darker and lighter values. The circular strokes do not need to be perfect, especially in the handle area, because your goal is to re-create the rusty and rough areas as realistically as possible.

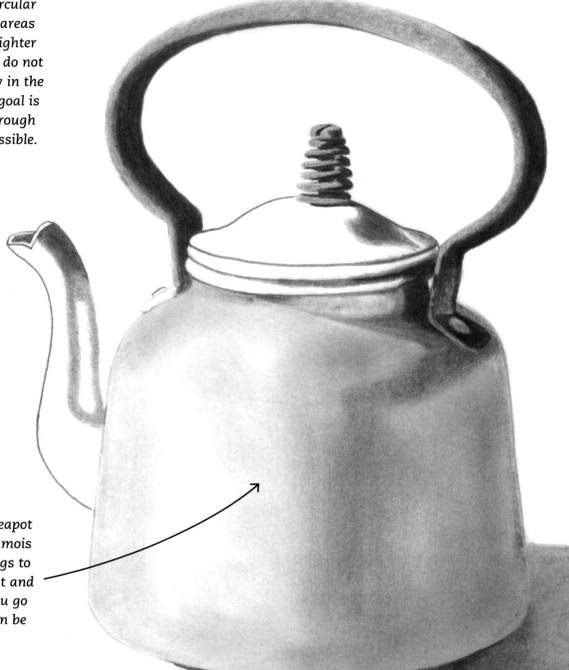

On the main body of the teapot I used a small piece of chamois dipped in graphite shavings to create the more subtle light and dark values. Any lines you go over with the chamois can be easily erased later.

For your outline, use a sharp HB or 2B pencil with very light pressure, which will be easier to erase later.

Using a 4B pencil, fill in the darkest values to the right of the spring handle.

With a circular motion, fill in the remaining portions of the handle, and use a tortillon to help blend the shadows.

Using a large, older blending stump also dipped in saved graphite shavings, create the subtle dark and light values on the teapot lid and spout. Again, test this method first on a separate piece of drawing paper.

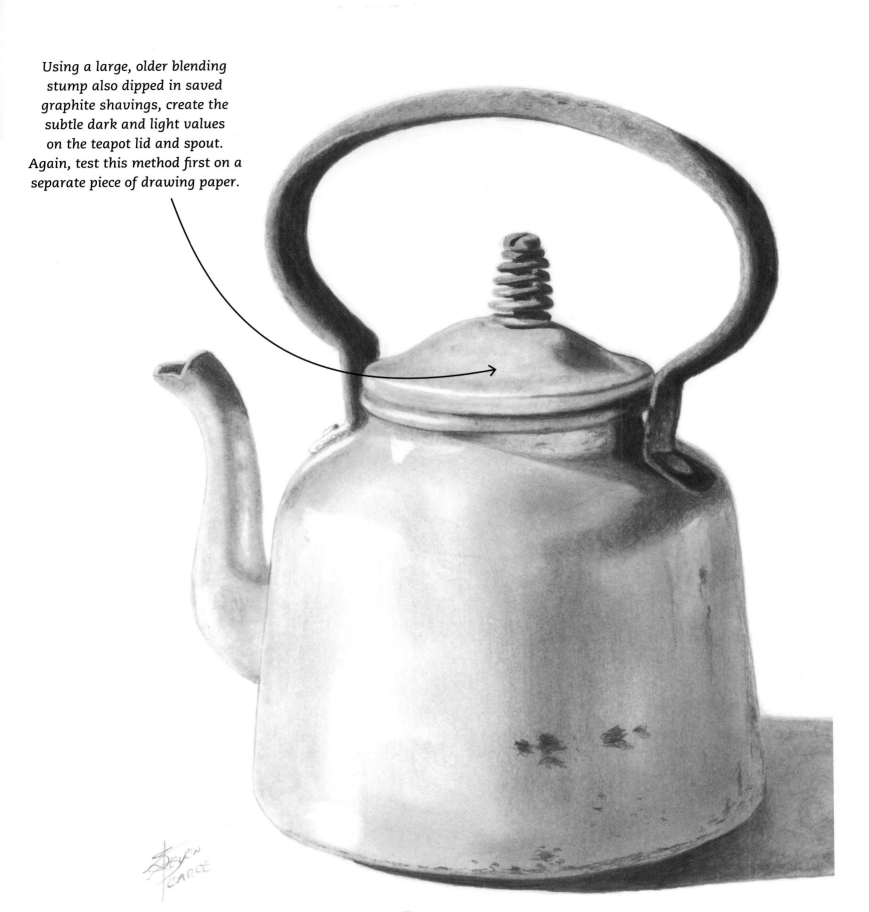

TIP

Before using the chamois blending technique, always test it on a separate piece of the same drawing paper to establish the values you want to apply to your original drawing.

Finish by adding some of the dark markings on the teapot and handle. Use a pencil eraser with the tip cut at an angle to bring out the sharper highlighted areas in the teapot body, lid, and handle. Use a kneaded eraser to bring out the more subtle lighter areas in the teapot.

ADDING DETAIL

This composition of an old rusty pipe wrench hanging on a wooden background provides a great opportunity to practice subtle detail. The contrast of light and dark really give life to this drawing. The details of the wrench may seem challenging, but once you establish the proportions, the rest of the drawing should come relatively easily.

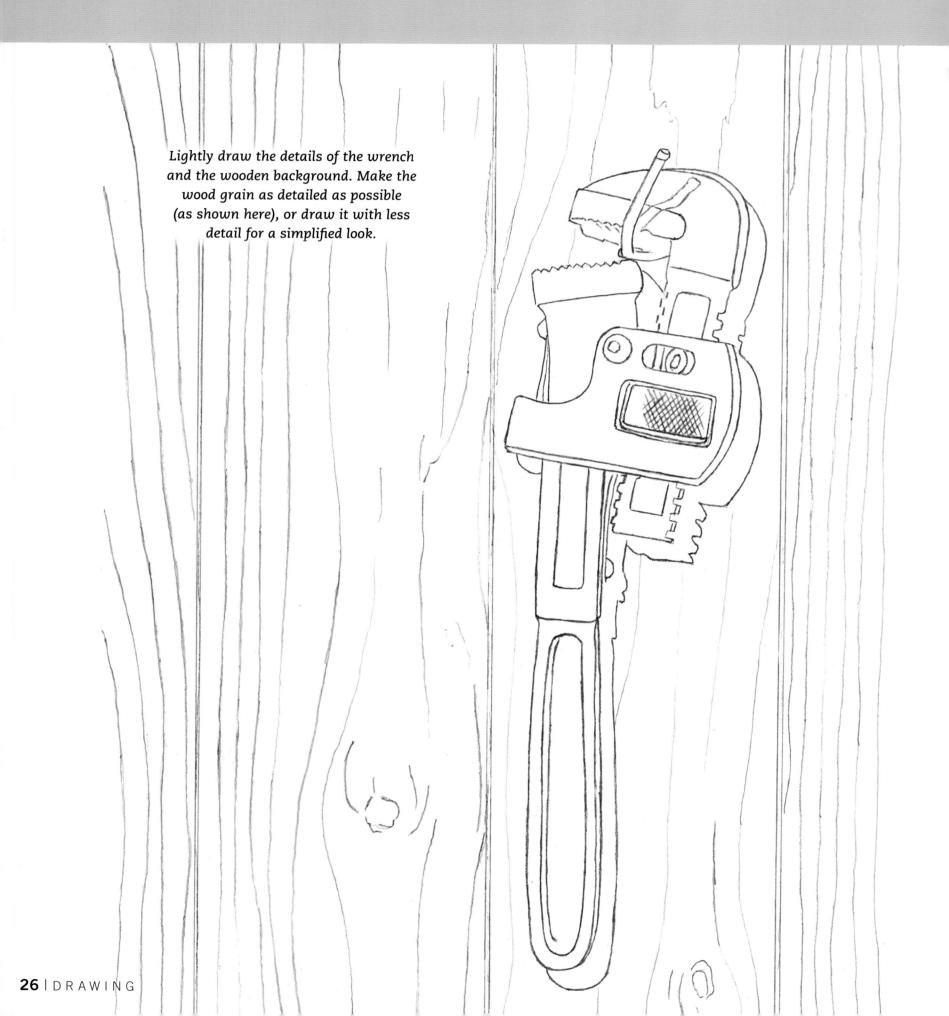

Lightly draw the details of the wrench and the wooden background. Make the wood grain as detailed as possible (as shown here), or draw it with less detail for a simplified look.

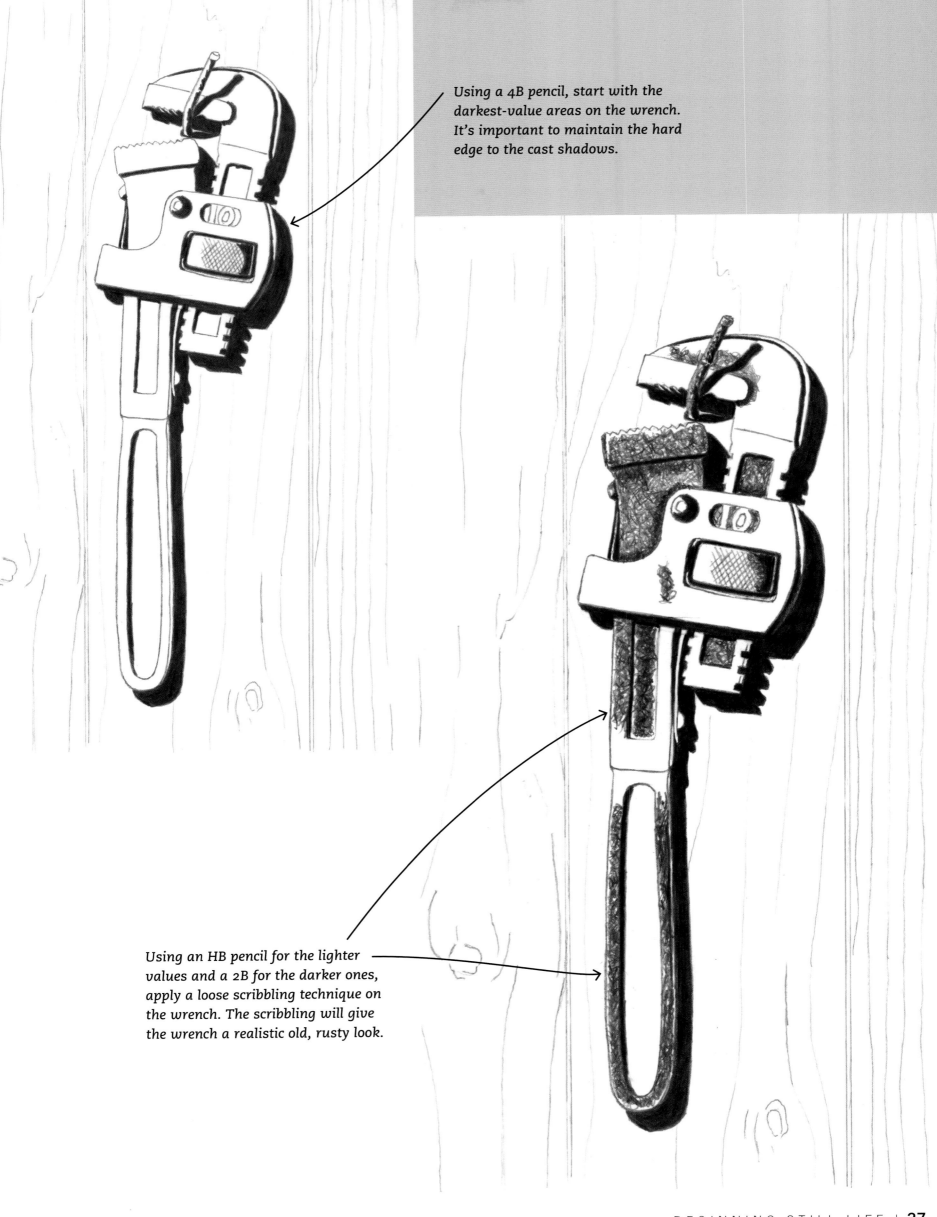

Using a 4B pencil, start with the darkest-value areas on the wrench. It's important to maintain the hard edge to the cast shadows.

Using an HB pencil for the lighter values and a 2B for the darker ones, apply a loose scribbling technique on the wrench. The scribbling will give the wrench a realistic old, rusty look.

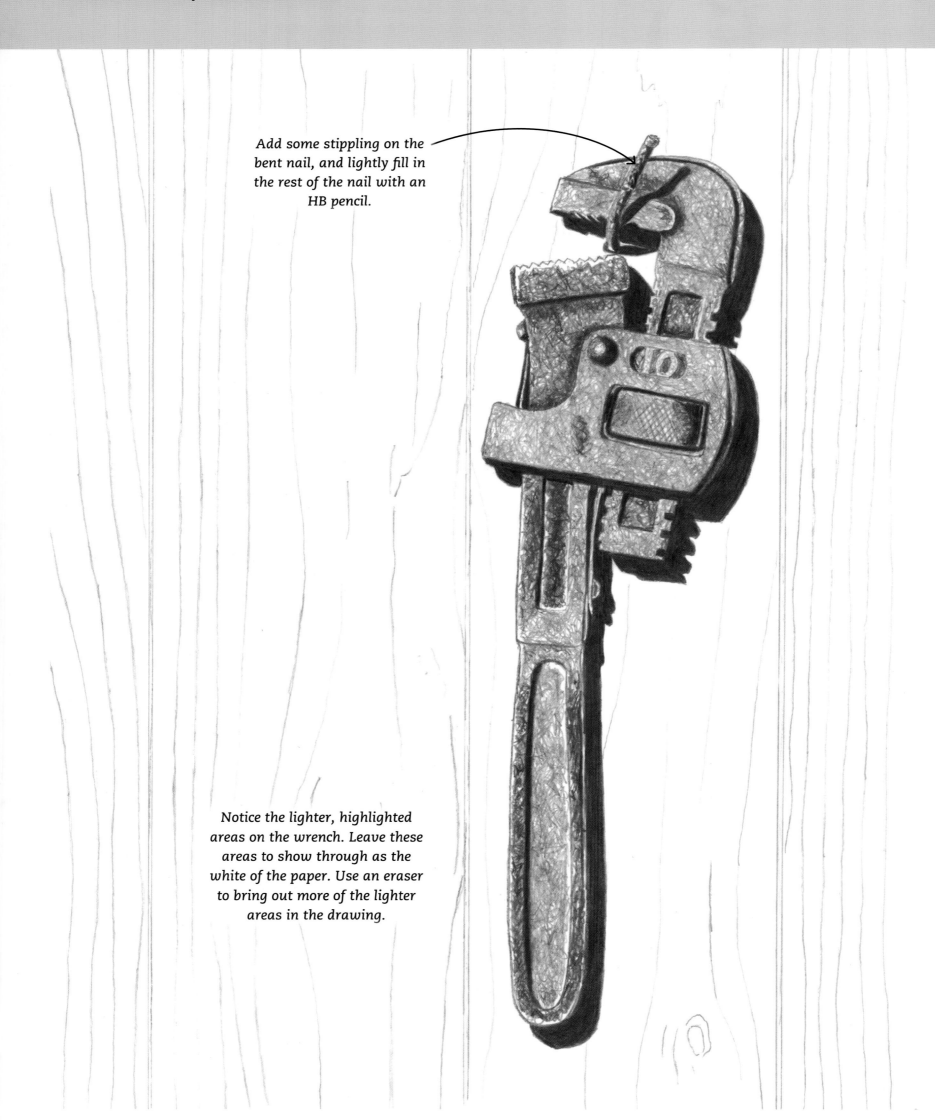

Add some stippling on the bent nail, and lightly fill in the rest of the nail with an HB pencil.

Notice the lighter, highlighted areas on the wrench. Leave these areas to show through as the white of the paper. Use an eraser to bring out more of the lighter areas in the drawing.

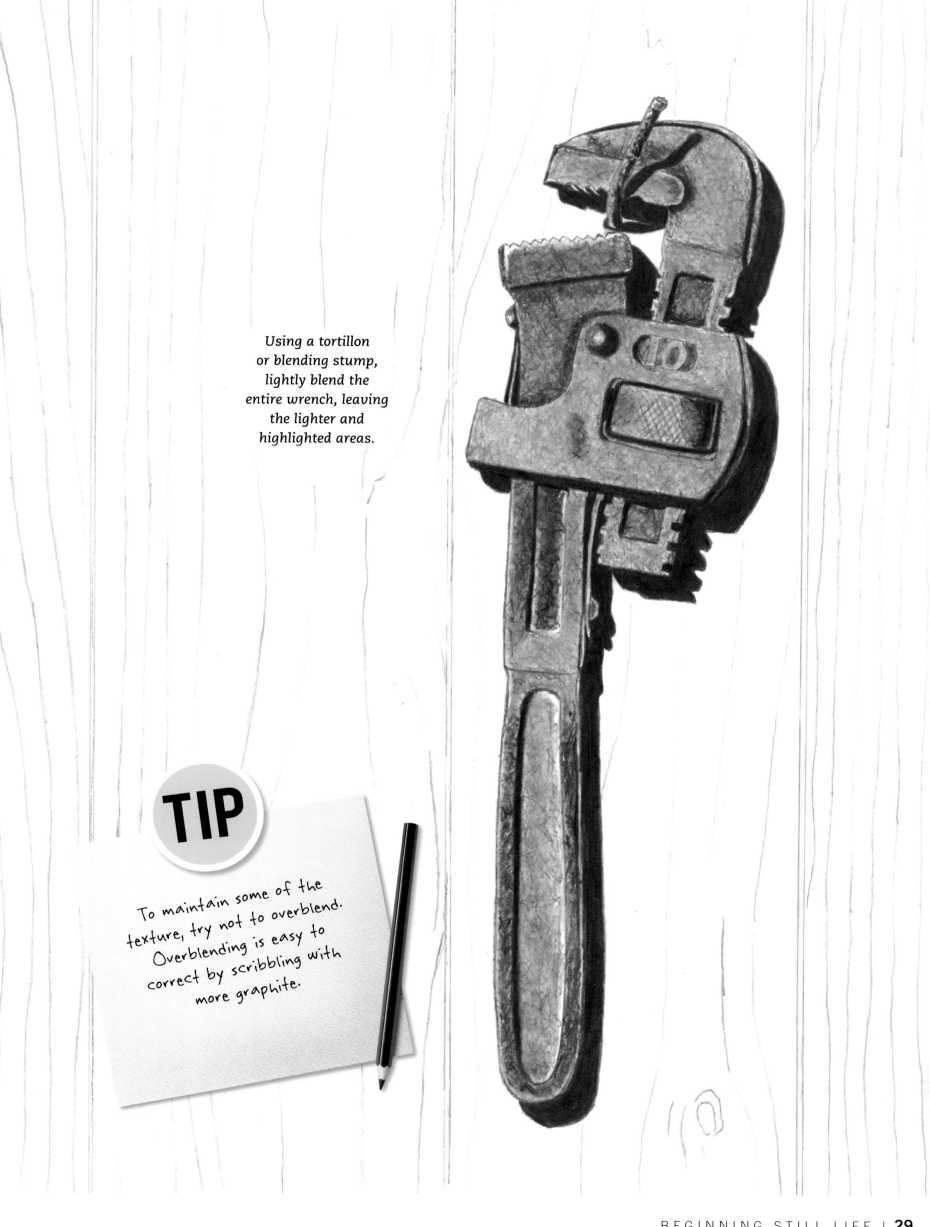

*Using a tortillon
or blending stump,
lightly blend the
entire wrench, leaving
the lighter and
highlighted areas.*

TIP

To maintain some of the texture, try not to overblend. Overblending is easy to correct by scribbling with more graphite.

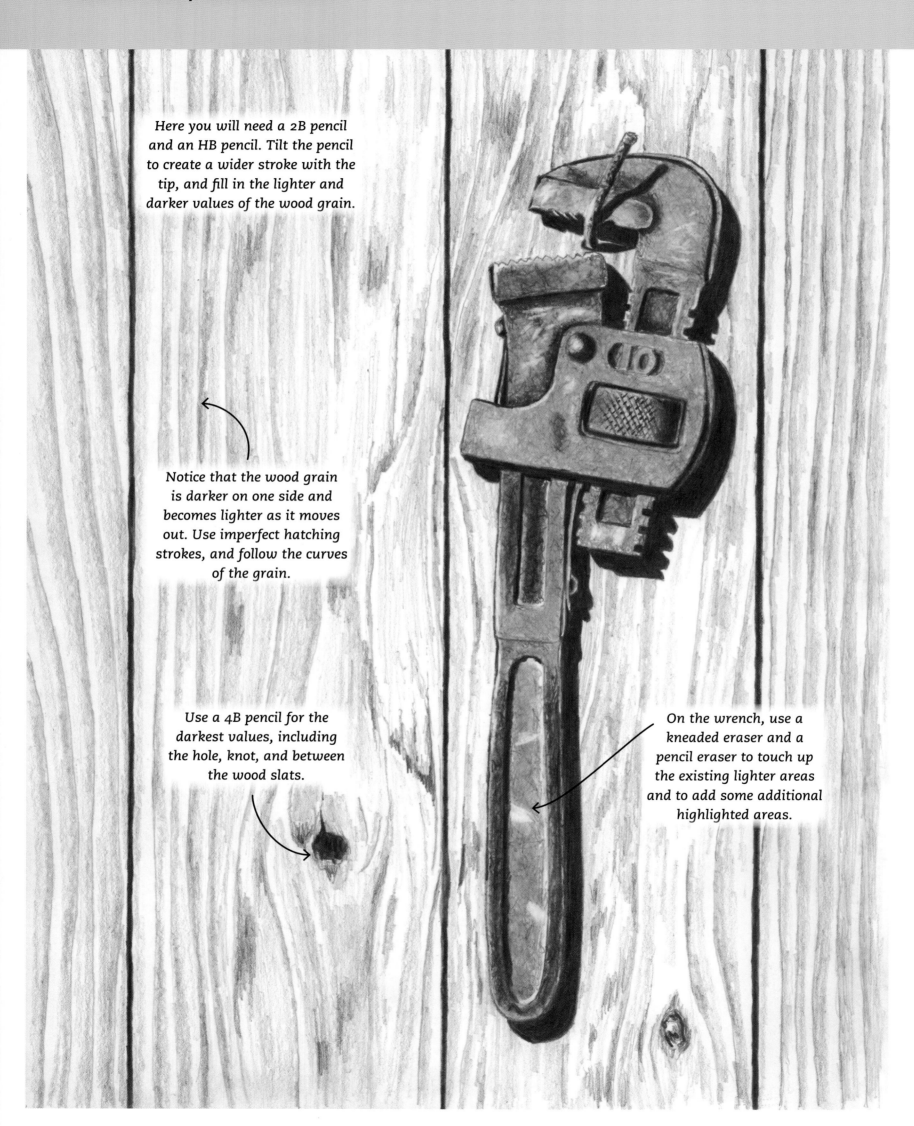

Here you will need a 2B pencil and an HB pencil. Tilt the pencil to create a wider stroke with the tip, and fill in the lighter and darker values of the wood grain.

Notice that the wood grain is darker on one side and becomes lighter as it moves out. Use imperfect hatching strokes, and follow the curves of the grain.

Use a 4B pencil for the darkest values, including the hole, knot, and between the wood slats.

On the wrench, use a kneaded eraser and a pencil eraser to touch up the existing lighter areas and to add some additional highlighted areas.

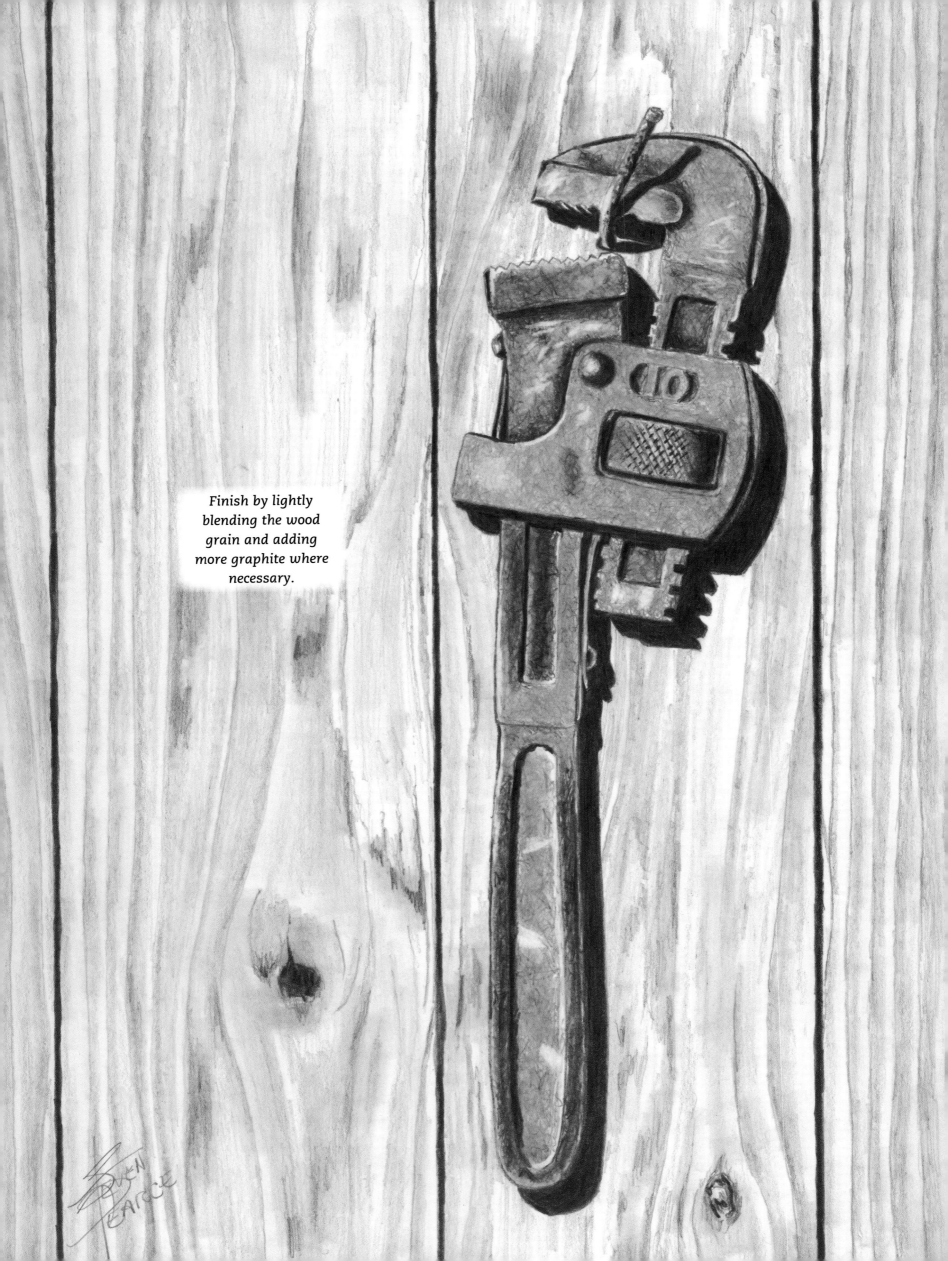

Finish by lightly blending the wood grain and adding more graphite where necessary.

TEXTURE & SHADING

Now that we have discussed value, perspective, and composition, it's time to develop texture and shading. The varying skin tones in these pears and the texture and shadows in the bowl make this a dynamic and lively subject to practice basic pencil techniques.

Sketch the basic outline onto drawing paper. You will erase the lines on the table later, but for now, use them as guidelines for the direction of the table's grain.

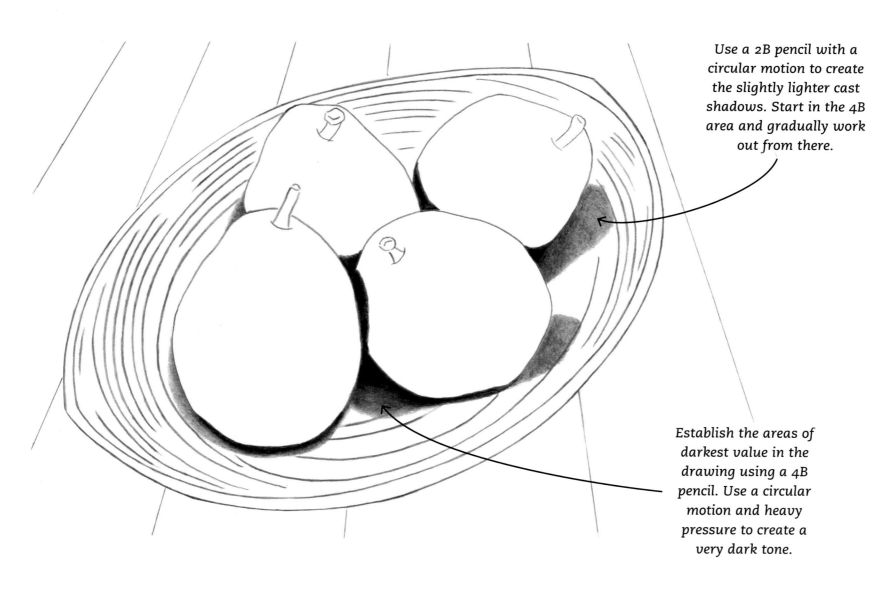

Use a 2B pencil with a circular motion to create the slightly lighter cast shadows. Start in the 4B area and gradually work out from there.

Establish the areas of darkest value in the drawing using a 4B pencil. Use a circular motion and heavy pressure to create a very dark tone.

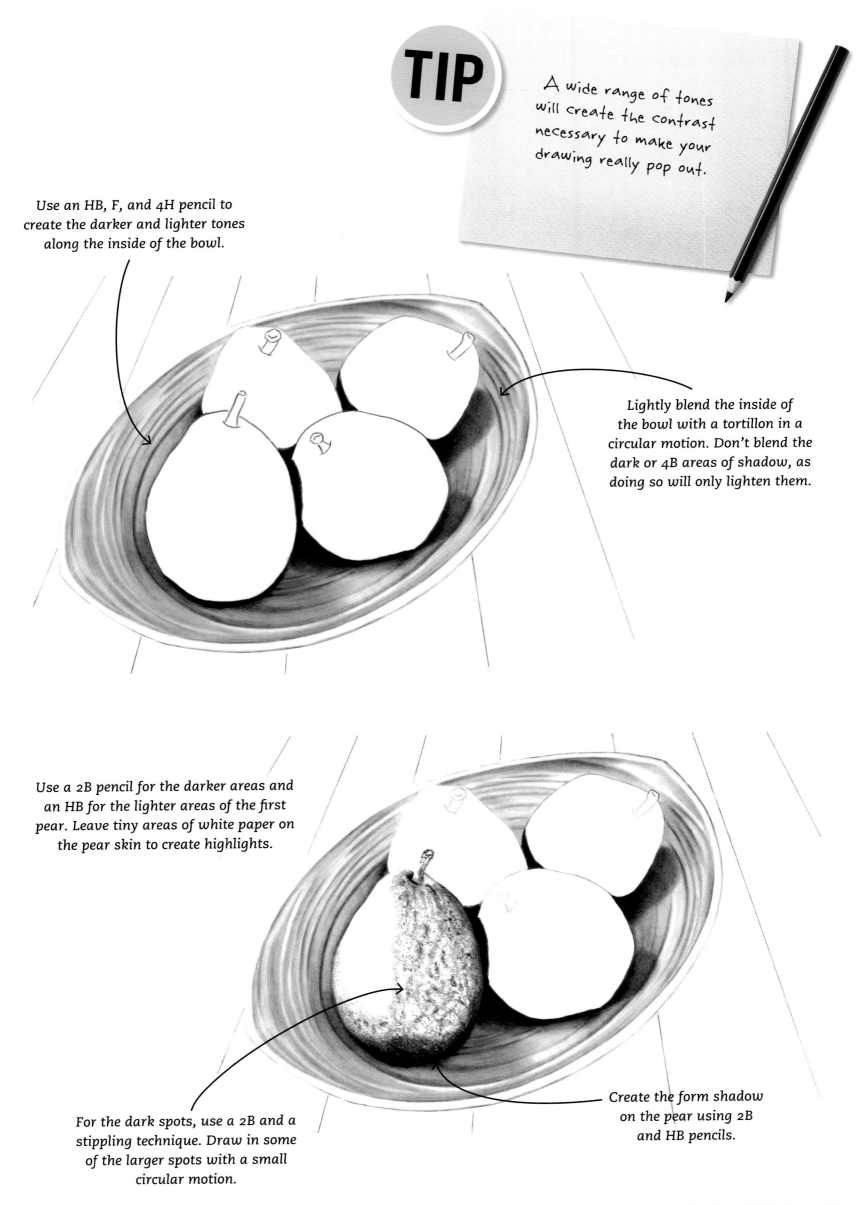

A wide range of tones will create the contrast necessary to make your drawing really pop out.

Use an HB, F, and 4H pencil to create the darker and lighter tones along the inside of the bowl.

Lightly blend the inside of the bowl with a tortillon in a circular motion. Don't blend the dark or 4B areas of shadow, as doing so will only lighten them.

Use a 2B pencil for the darker areas and an HB for the lighter areas of the first pear. Leave tiny areas of white paper on the pear skin to create highlights.

For the dark spots, use a 2B and a stippling technique. Draw in some of the larger spots with a small circular motion.

Create the form shadow on the pear using 2B and HB pencils.

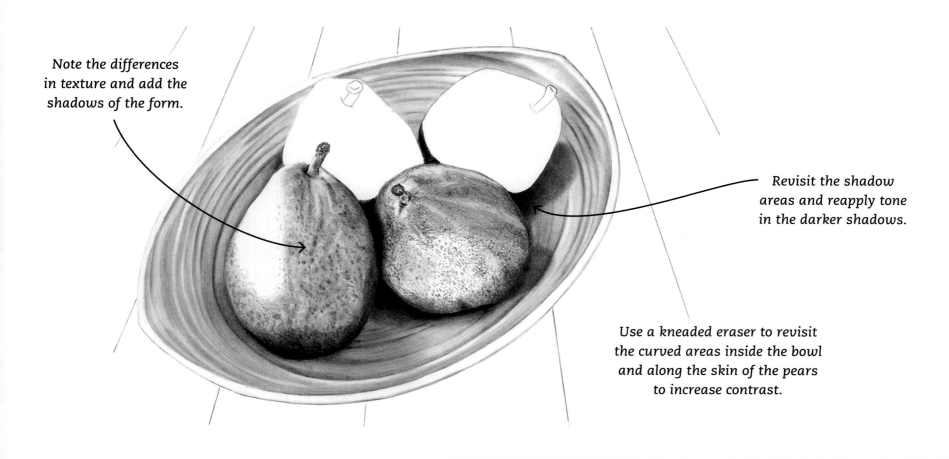

Note the differences in texture and add the shadows of the form.

Revisit the shadow areas and reapply tone in the darker shadows.

Use a kneaded eraser to revisit the curved areas inside the bowl and along the skin of the pears to increase contrast.

Each of the pears has some differences in texture. For the smoother areas, I use an HB and a tight circular motion. I blend each pear and stem as I go along, using a tortillon with a light circular motion.

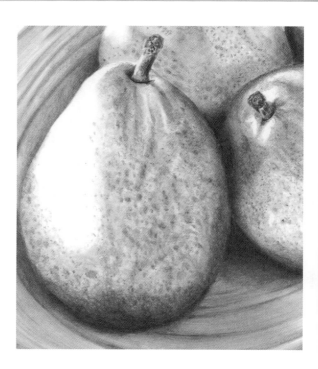

TIP

Practice stippling and creating the "loose" circular texture for the pears on a separate sheet of paper using sharp and dull pencil tips.

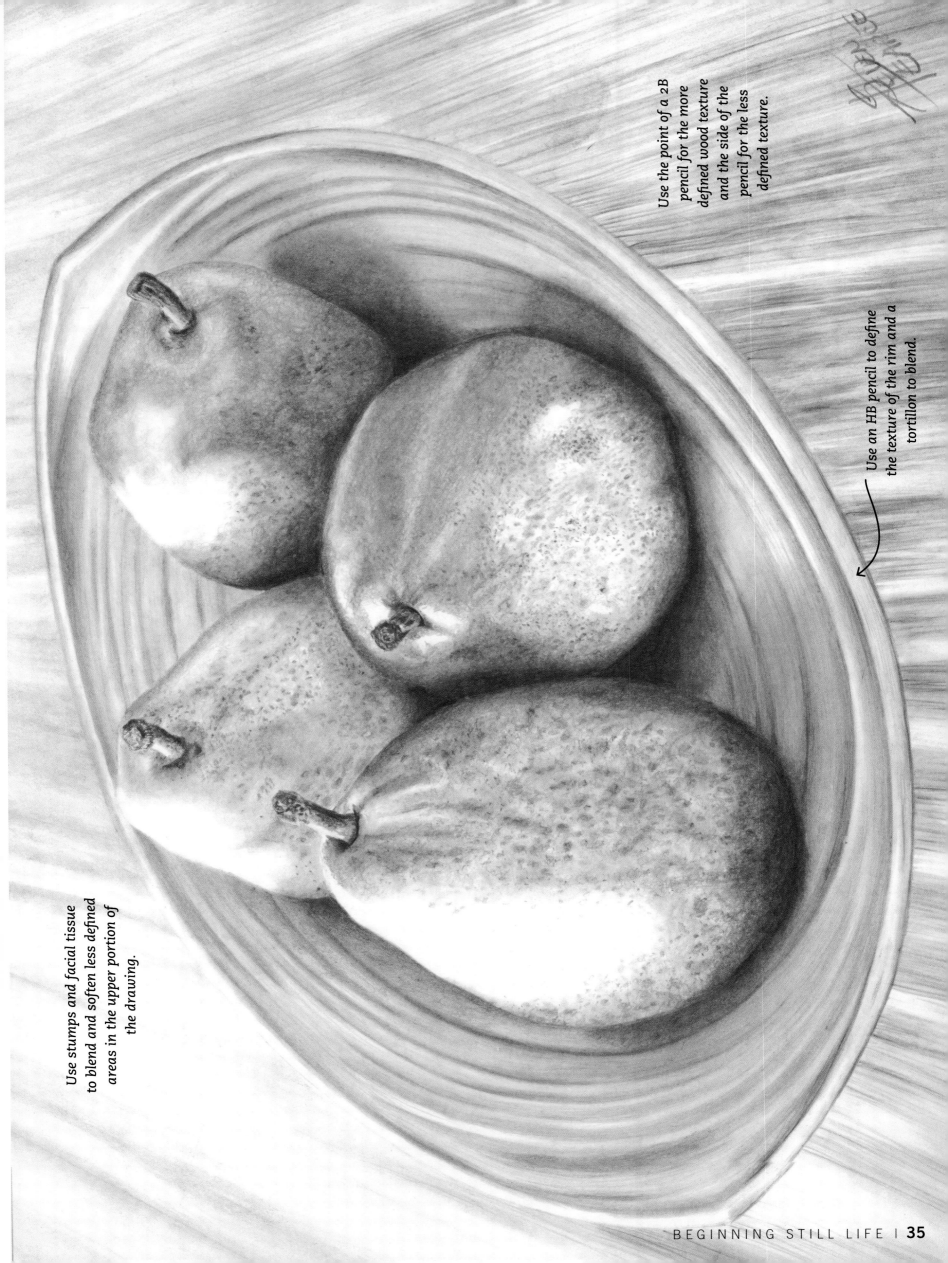

Use the point of a 2B pencil for the more defined wood texture and the side of the pencil for the less defined texture.

Use an HB pencil to define the texture of the rim and a tortillon to blend.

Use stumps and facial tissue to blend and soften less defined areas in the upper portion of the drawing.

COMPOSITION

This simple still life of a pepper in a bowl beside a small tomato reinforces the importance of composition and placement within a drawing. The varying sizes and shapes as well as the texture and detail of the pepper and tomato provide interest and balance within the composition.

With very light lines, draw the simple shapes that make up the composition. The pepper is a slightly oval ellipse, and the tomato is round.

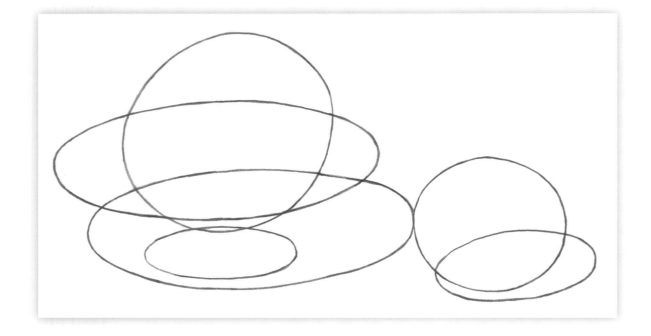

Define the shapes of the pepper, bowl, and tomato, including the stems and some of the more prominent shadow and highlighted areas.

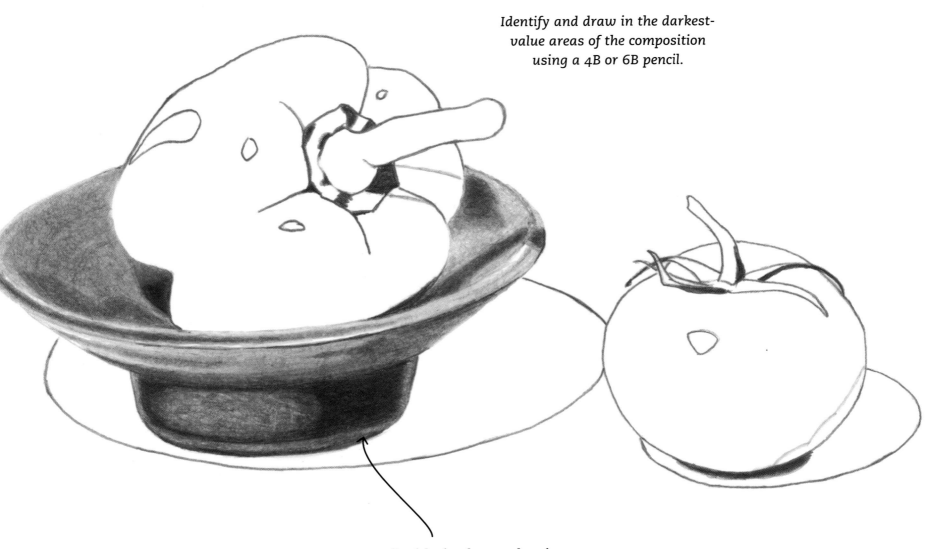

Identify and draw in the darkest-value areas of the composition using a 4B or 6B pencil.

Use a 2B pencil with circular overlapping strokes for the cast shadow and darker areas of the bowl. For the lighter areas, use an HB pencil and a 2H pencil.

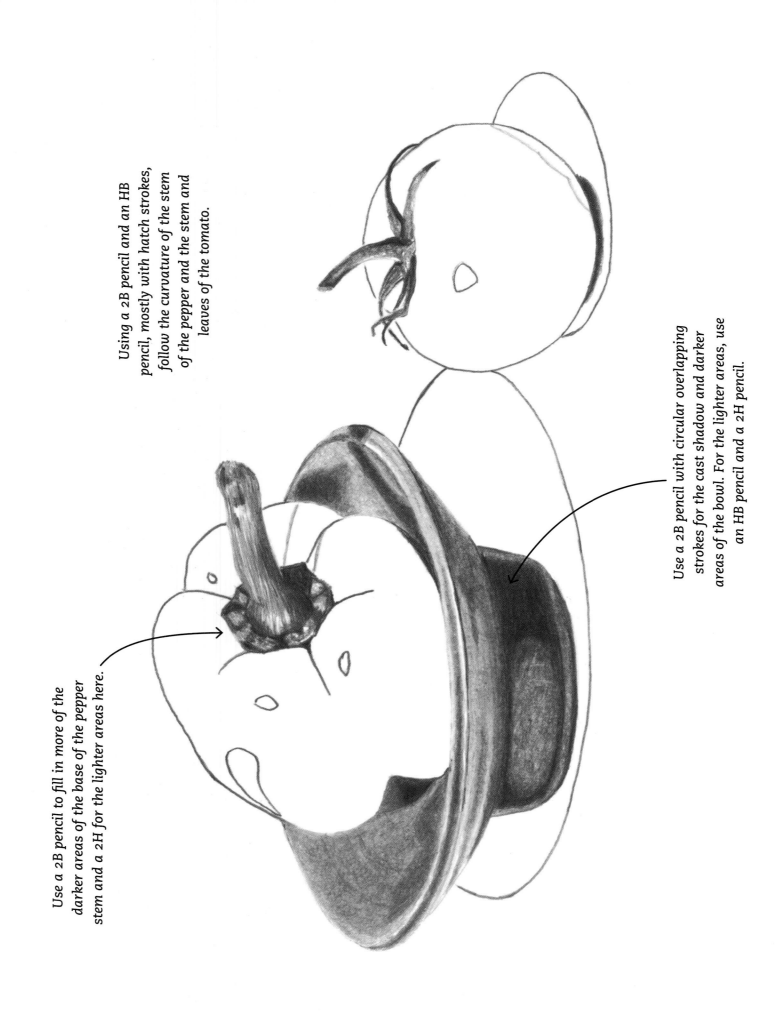

Using a 2B pencil and an HB pencil, mostly with hatch strokes, follow the curvature of the stem of the pepper and the stem and leaves of the tomato.

Use a 2B pencil with circular overlapping strokes for the cast shadow and darker areas of the bowl. For the lighter areas, use an HB pencil and a 2H pencil.

Use a 2B pencil to fill in more of the darker areas of the base of the pepper stem and a 2H for the lighter areas here.

Use a 2B pencil to make small, circular, overlapping strokes for the darkest areas of the pepper and tomato, including the cast shadow from the pepper stem. Then use an HB pencil and a 2H pencil for the other values of the pepper and tomato and the cast shadows of the bowl and tomato.

Leave the highlighted areas to be represented by the white of the paper.

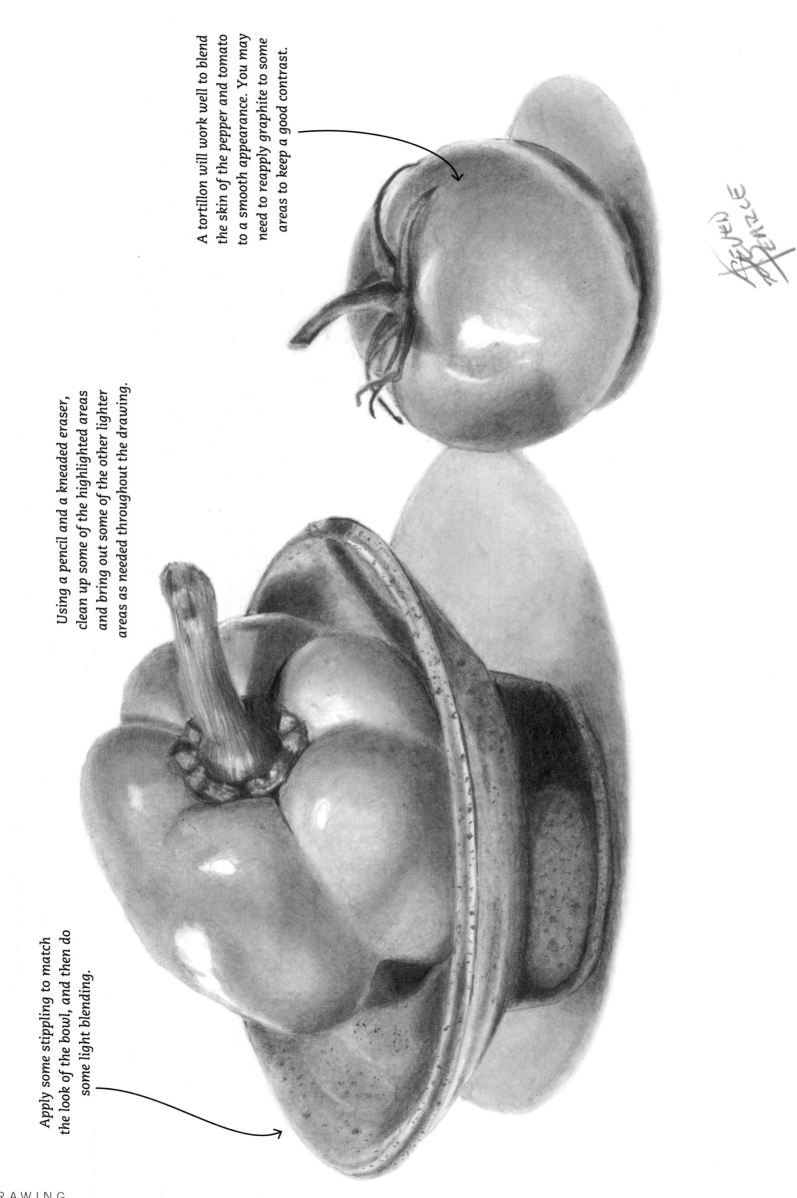

A tortillon will work well to blend the skin of the pepper and tomato to a smooth appearance. You may need to reapply graphite to some areas to keep a good contrast.

Using a pencil and a kneaded eraser, clean up some of the highlighted areas and bring out some of the other lighter areas as needed throughout the drawing.

Apply some stippling to match the look of the bowl, and then do some light blending.